Copyright © 2019 by Kami Long
All rights reserved. This book or any portion thereof
may not be reproduced or used in any manner whatsoever
without the express written permission of the publisher
except for the use of brief quotations in a book review.

Printed in the United States of America

First Printing, 2019

ISBN 978-1-79477-744-6

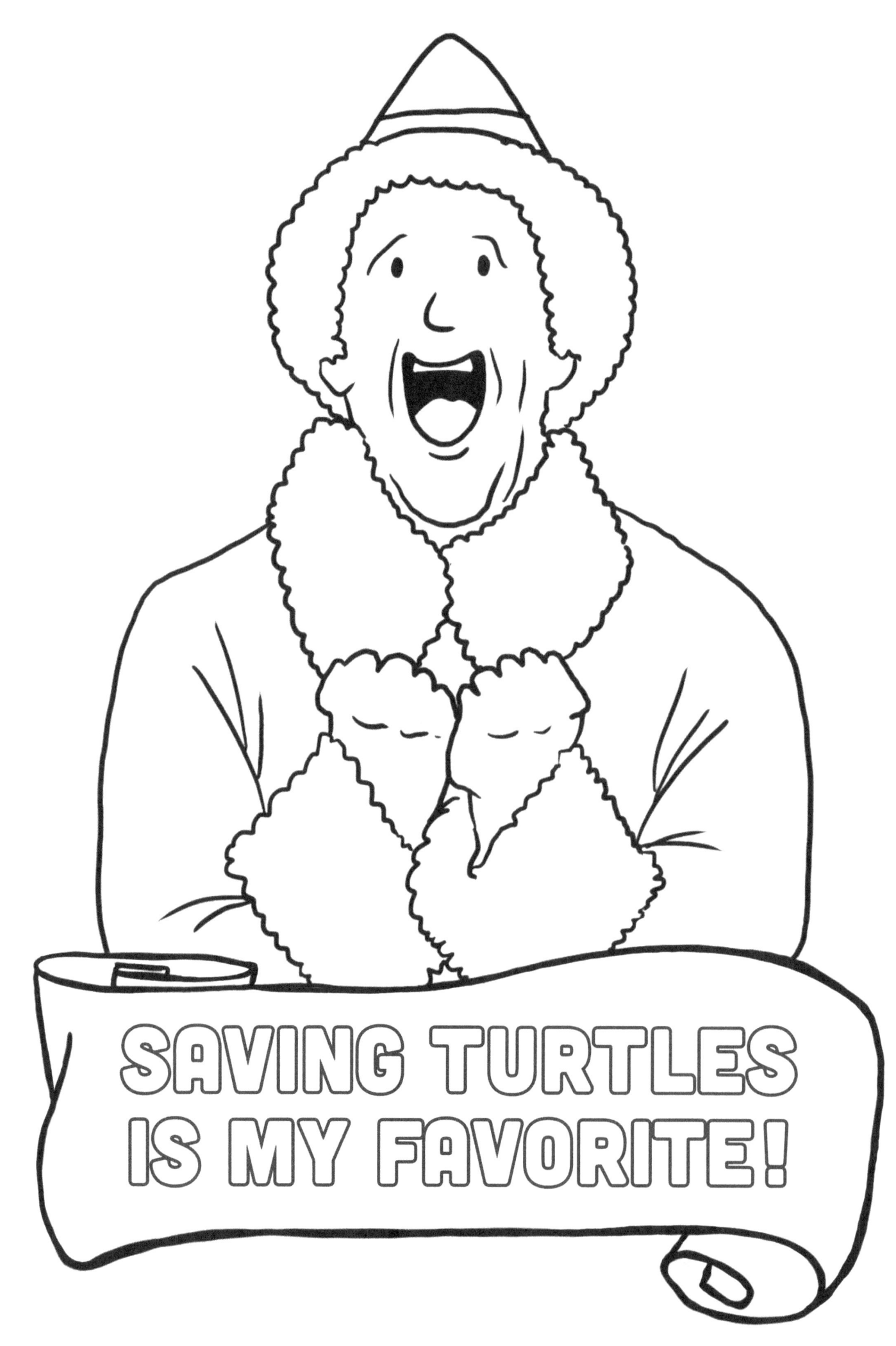

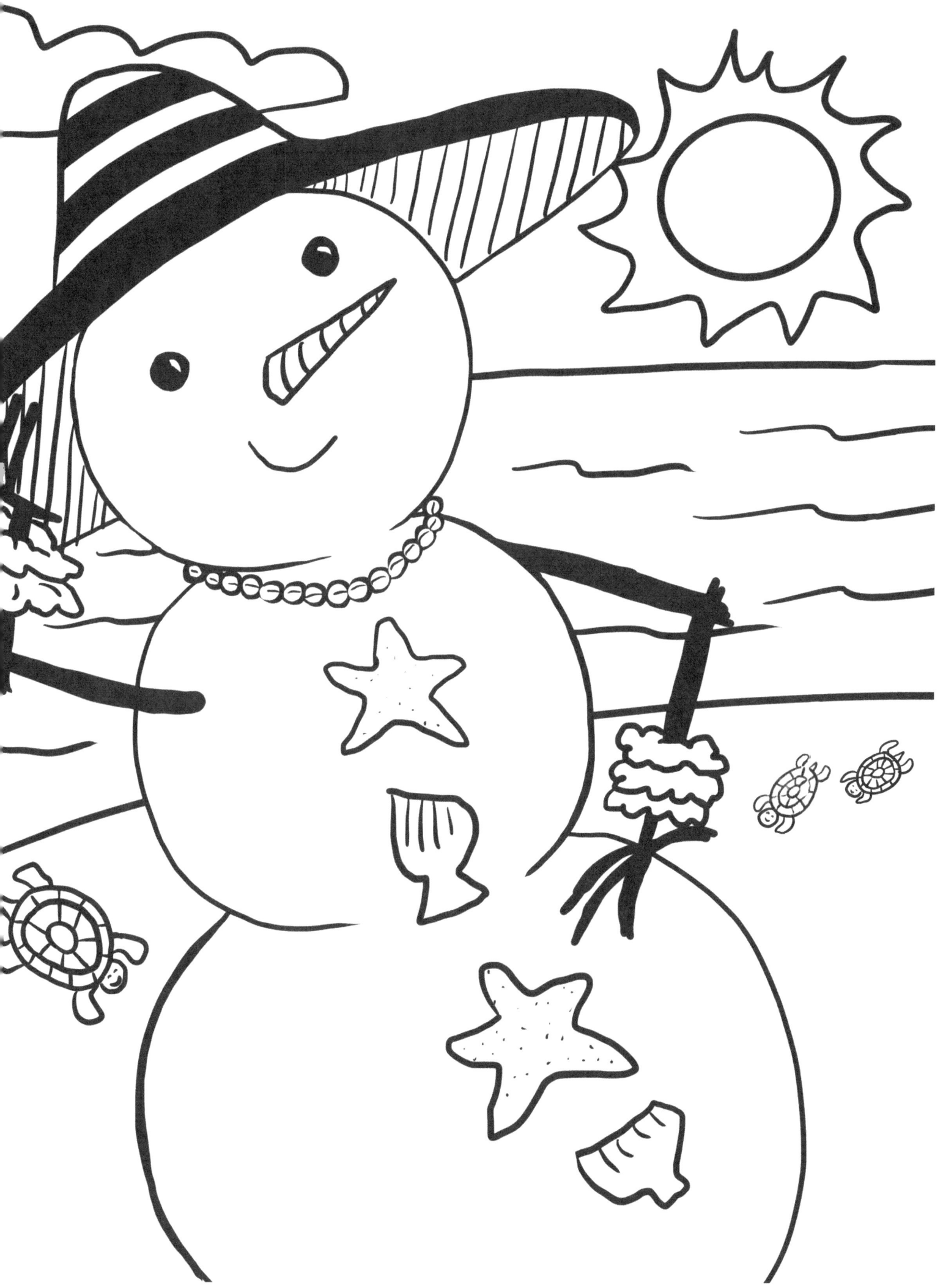

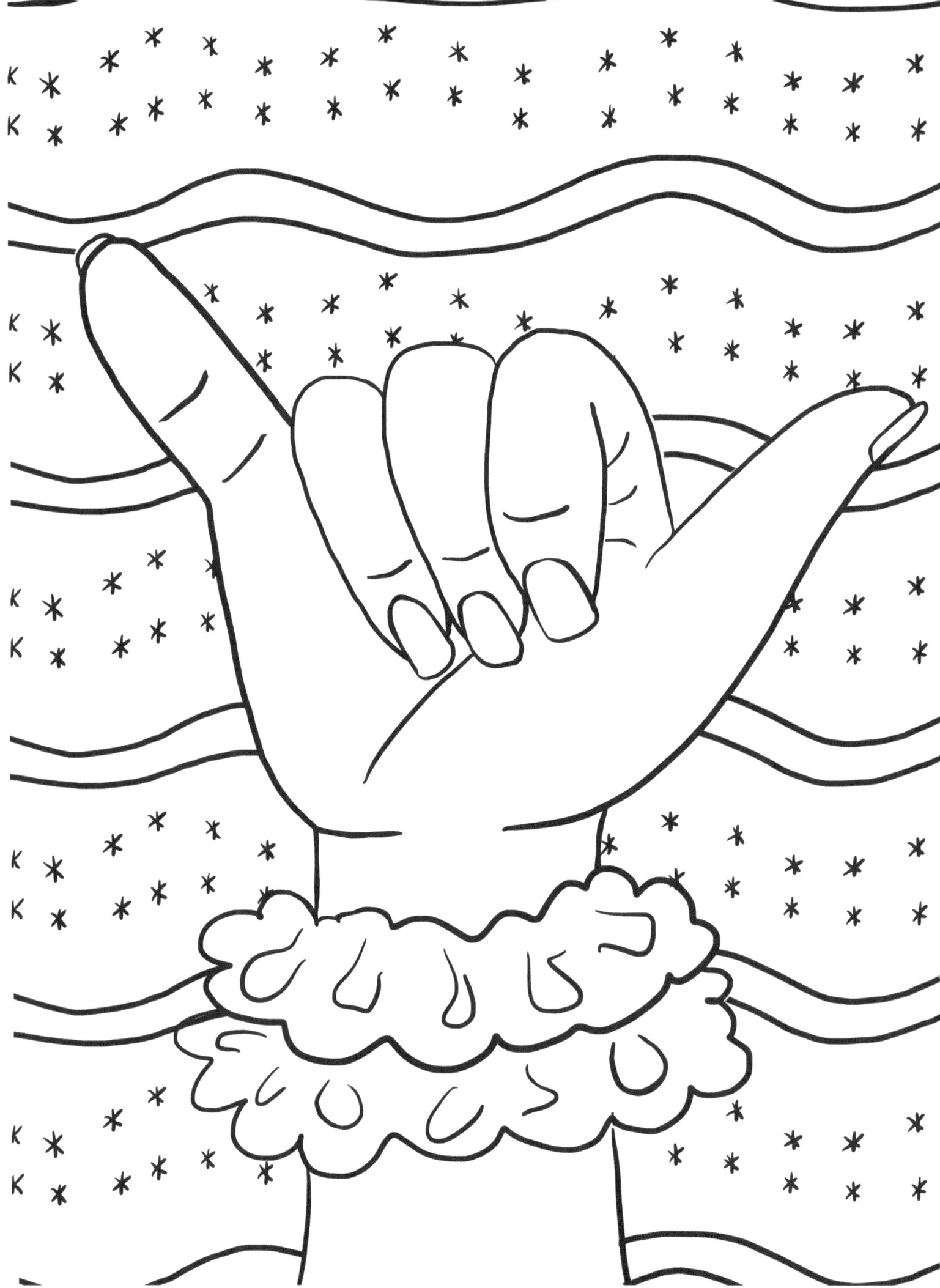

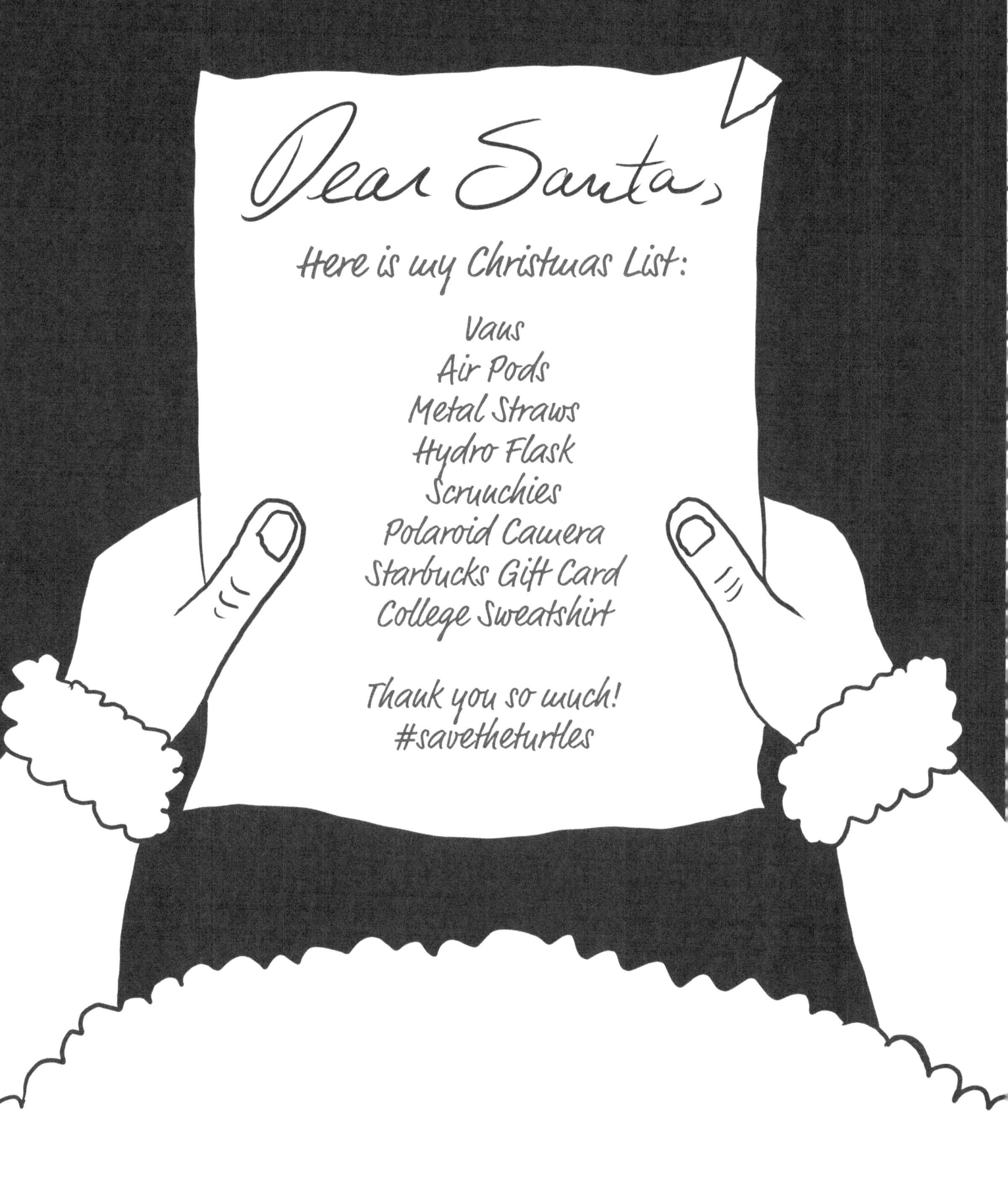

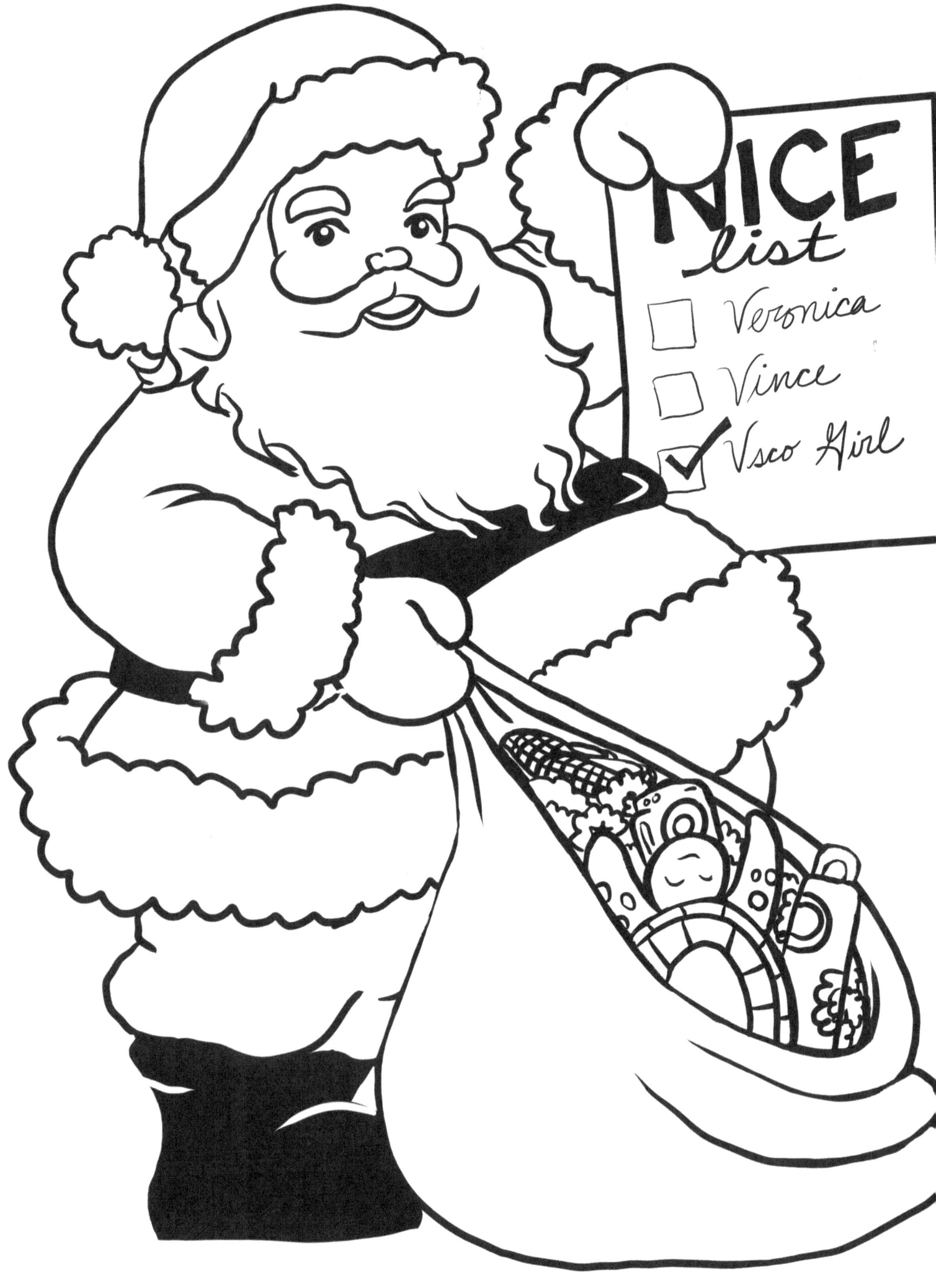

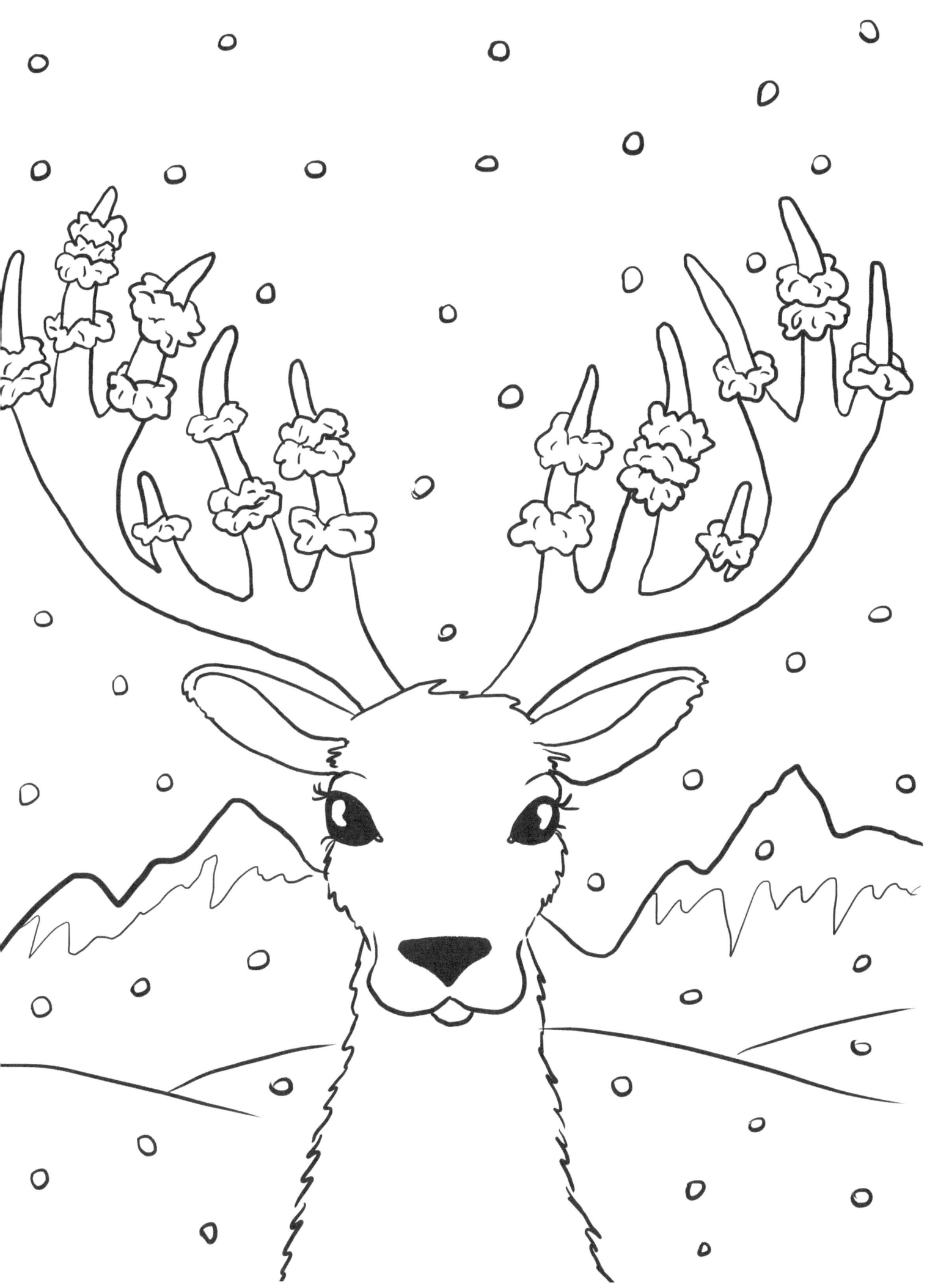

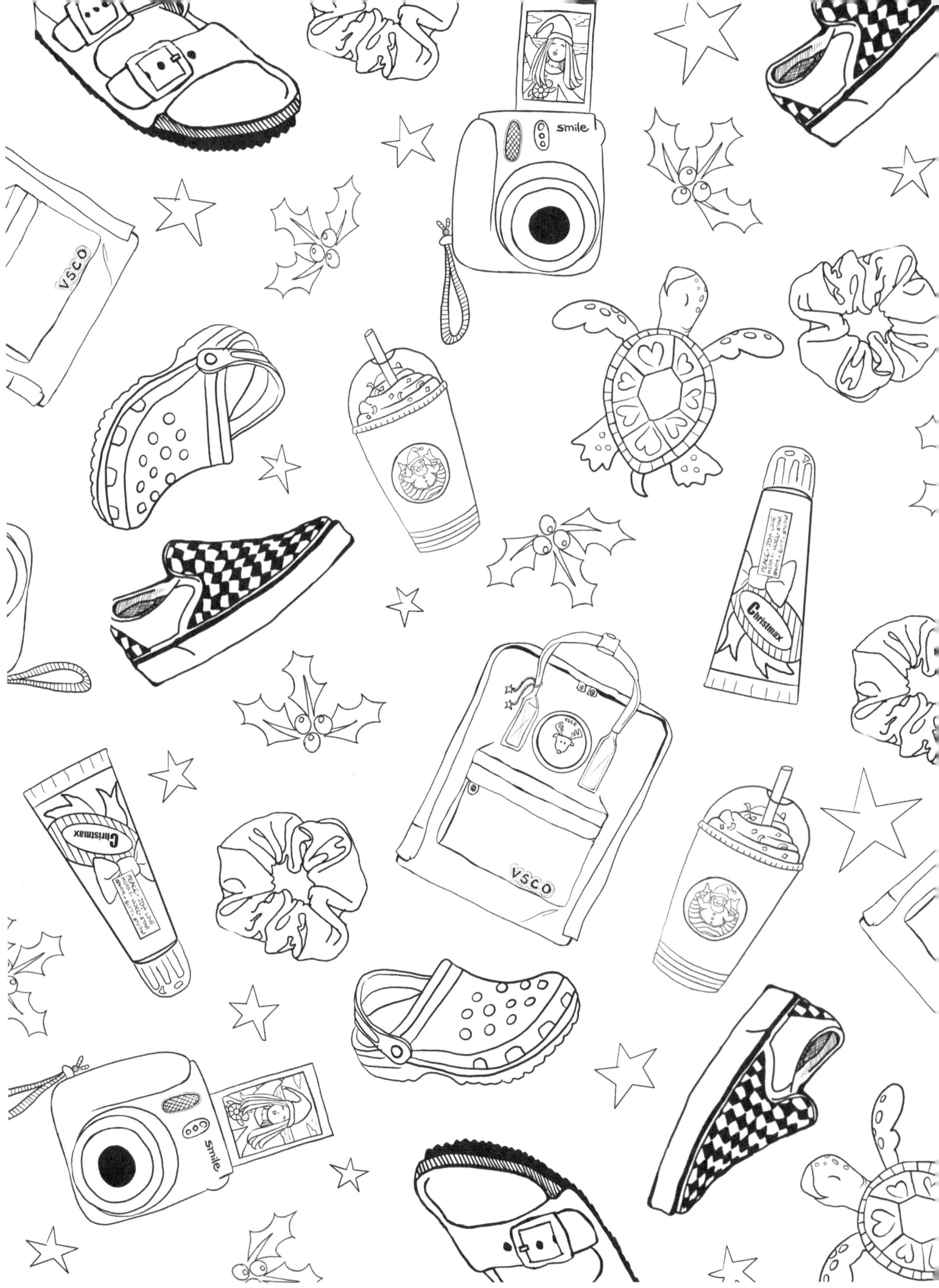

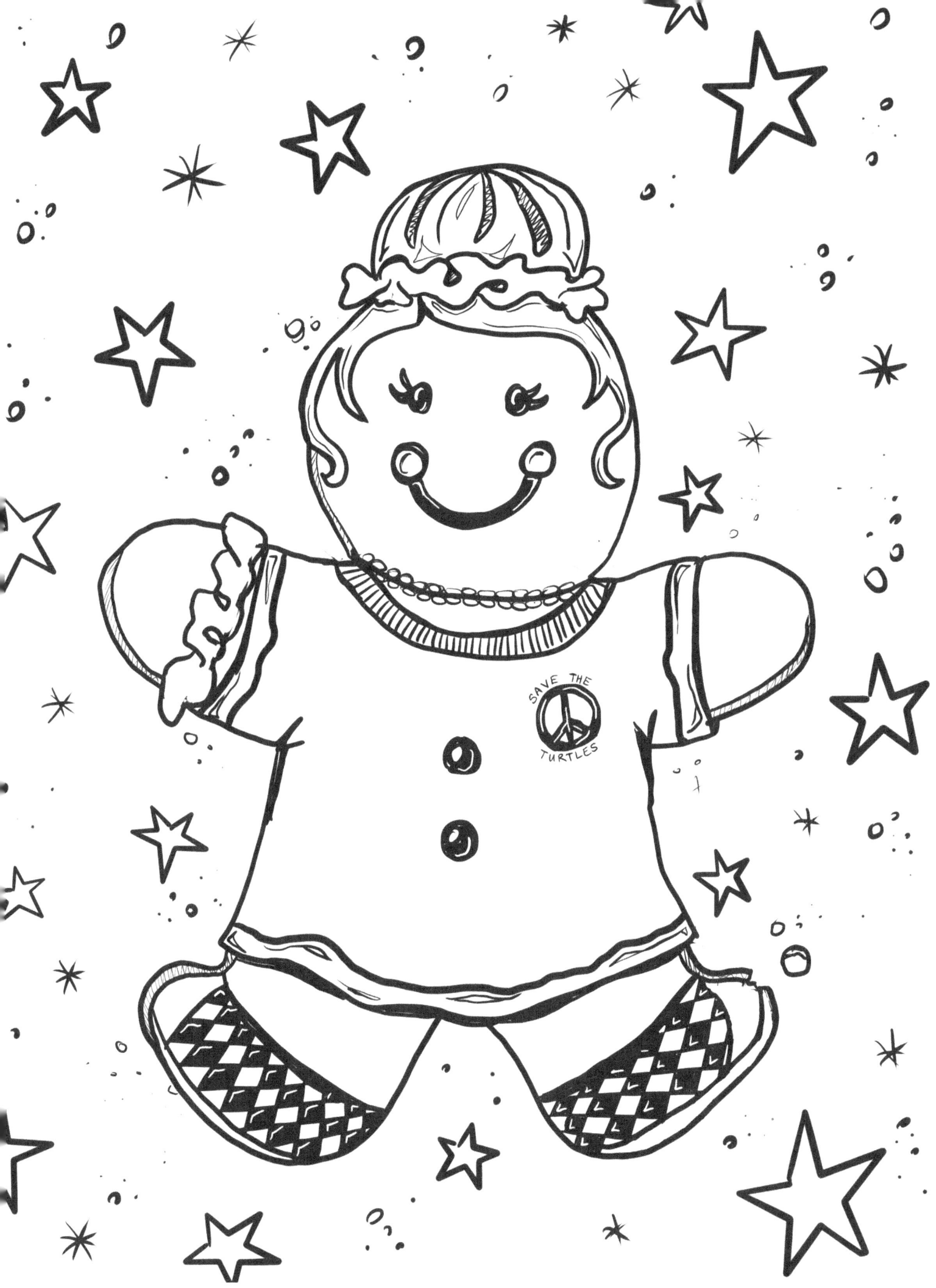

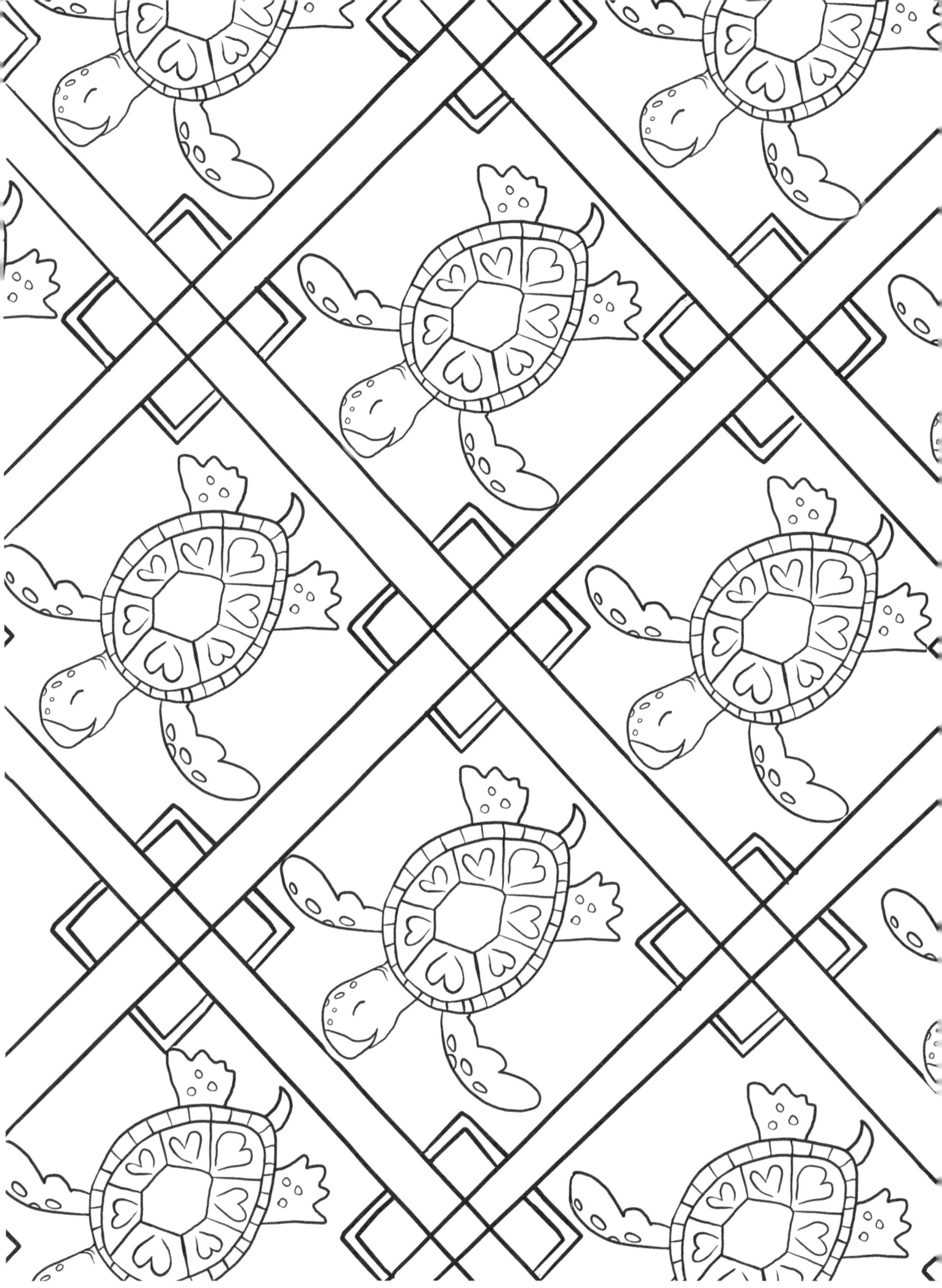

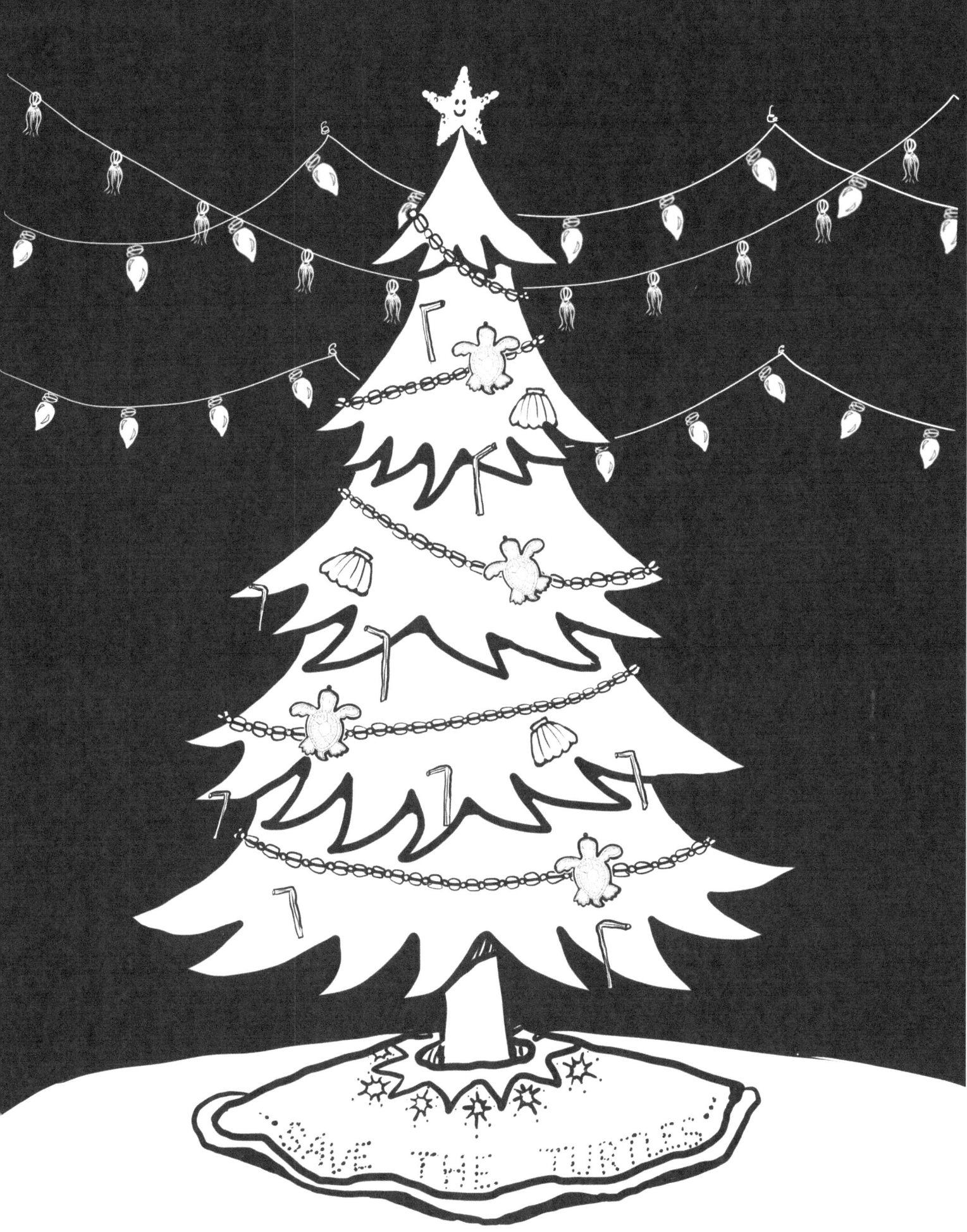

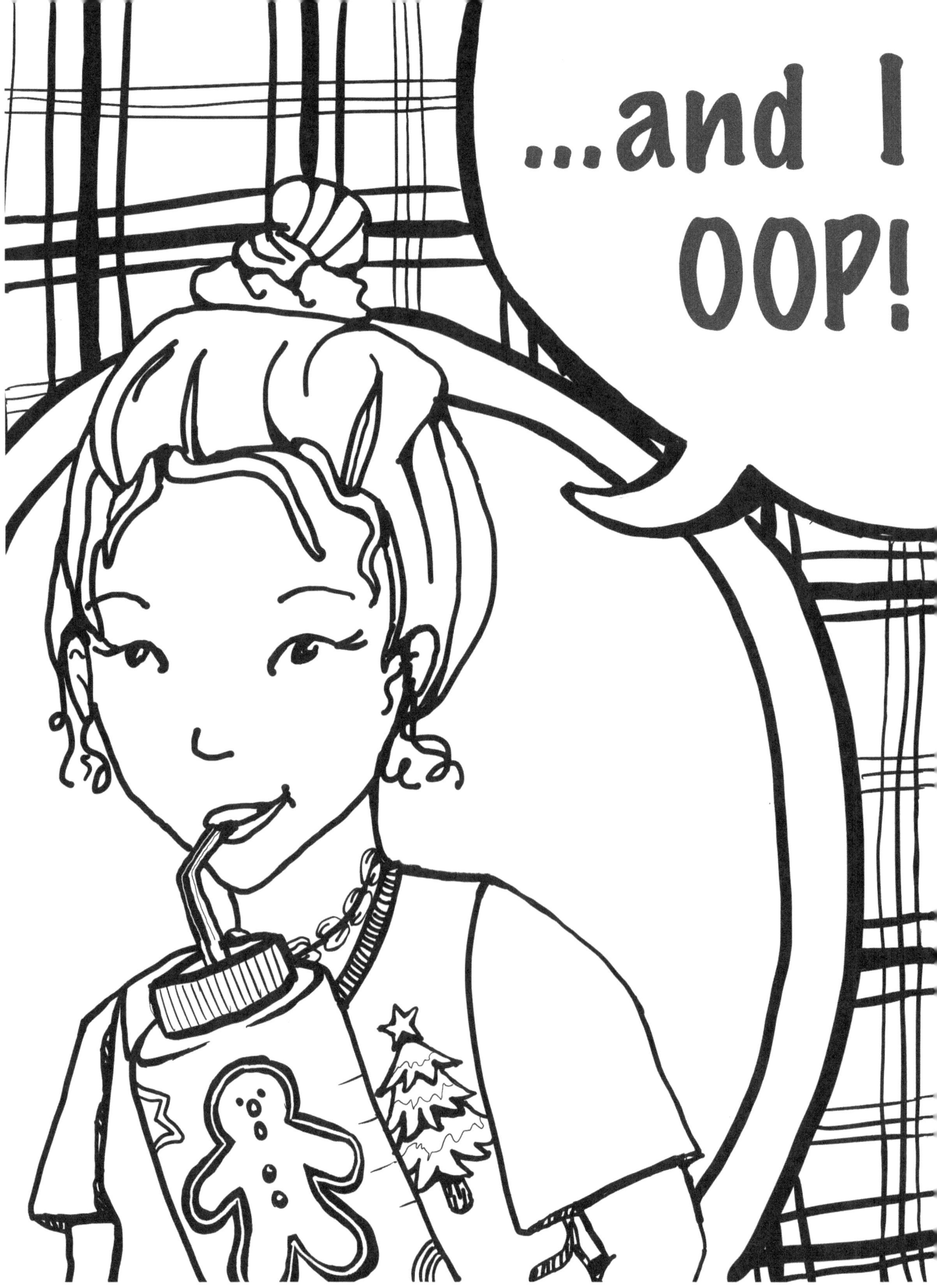

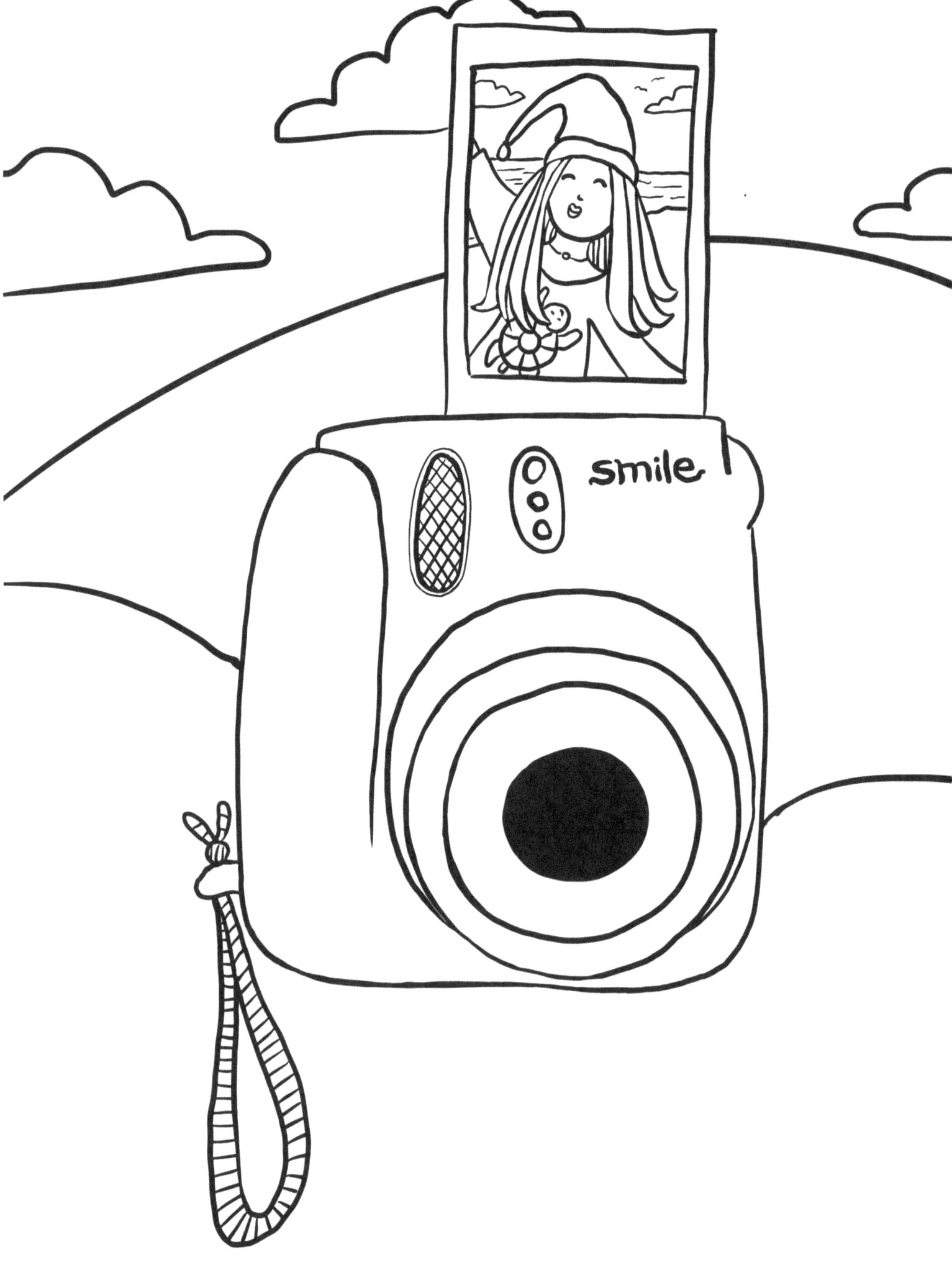

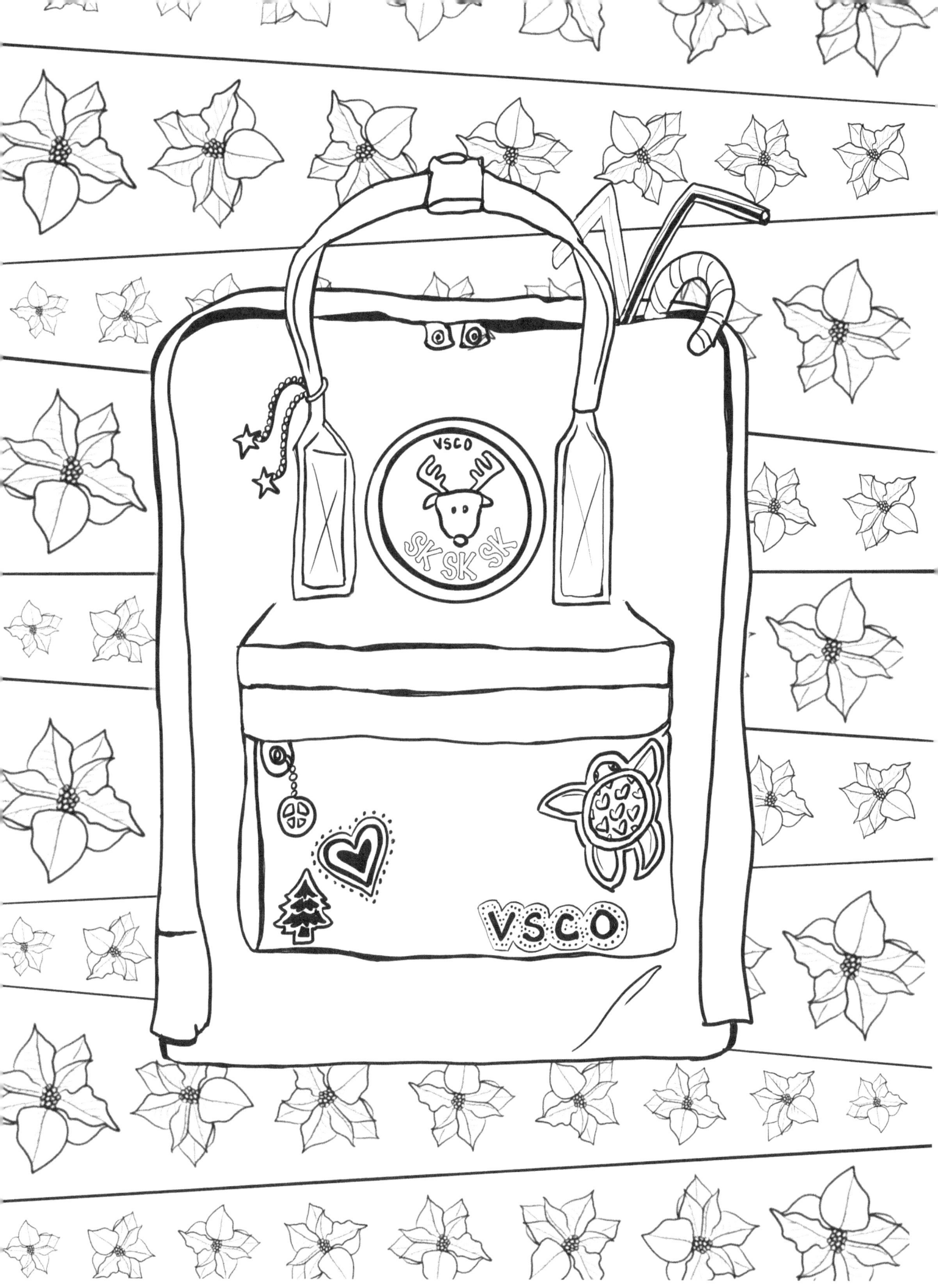

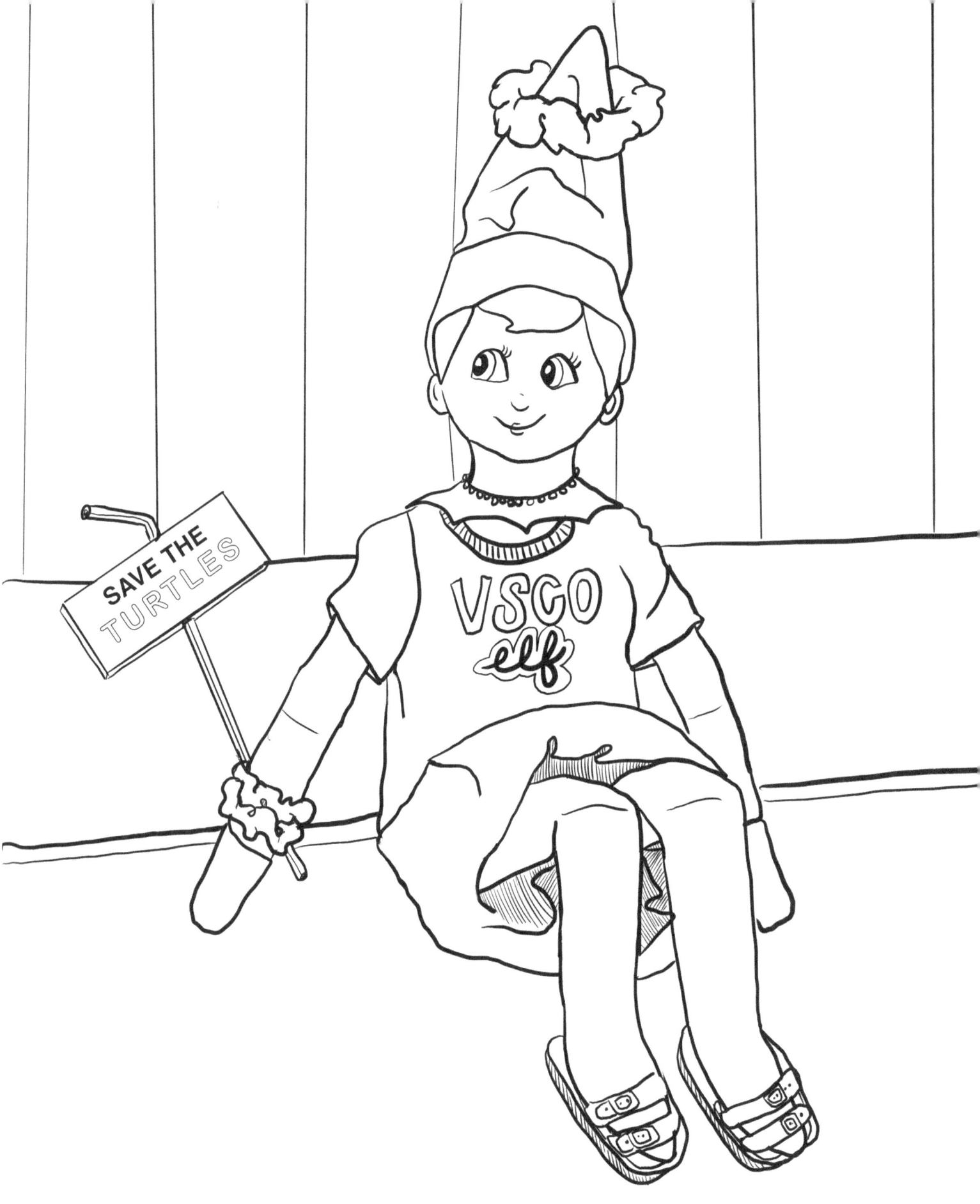

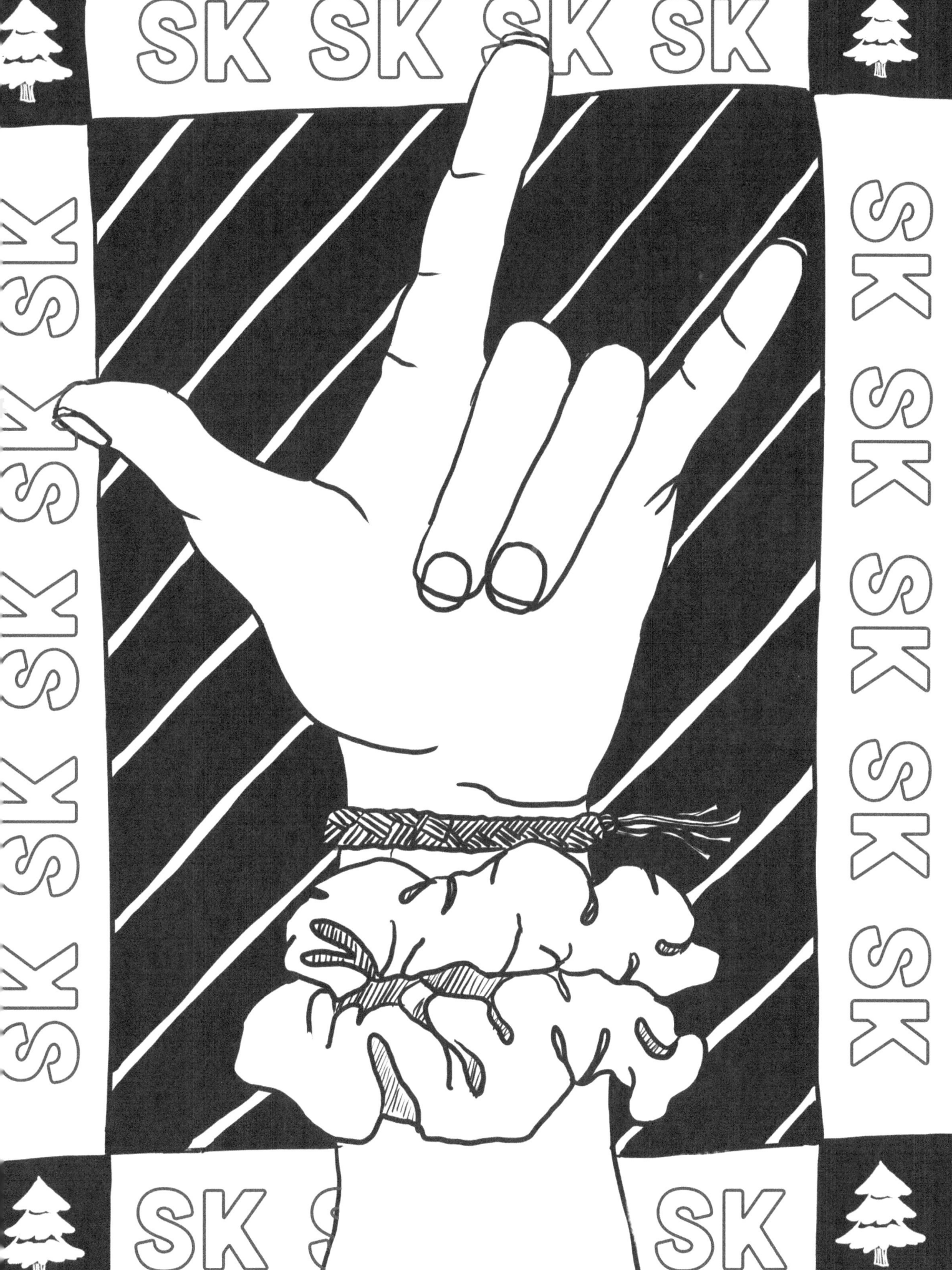

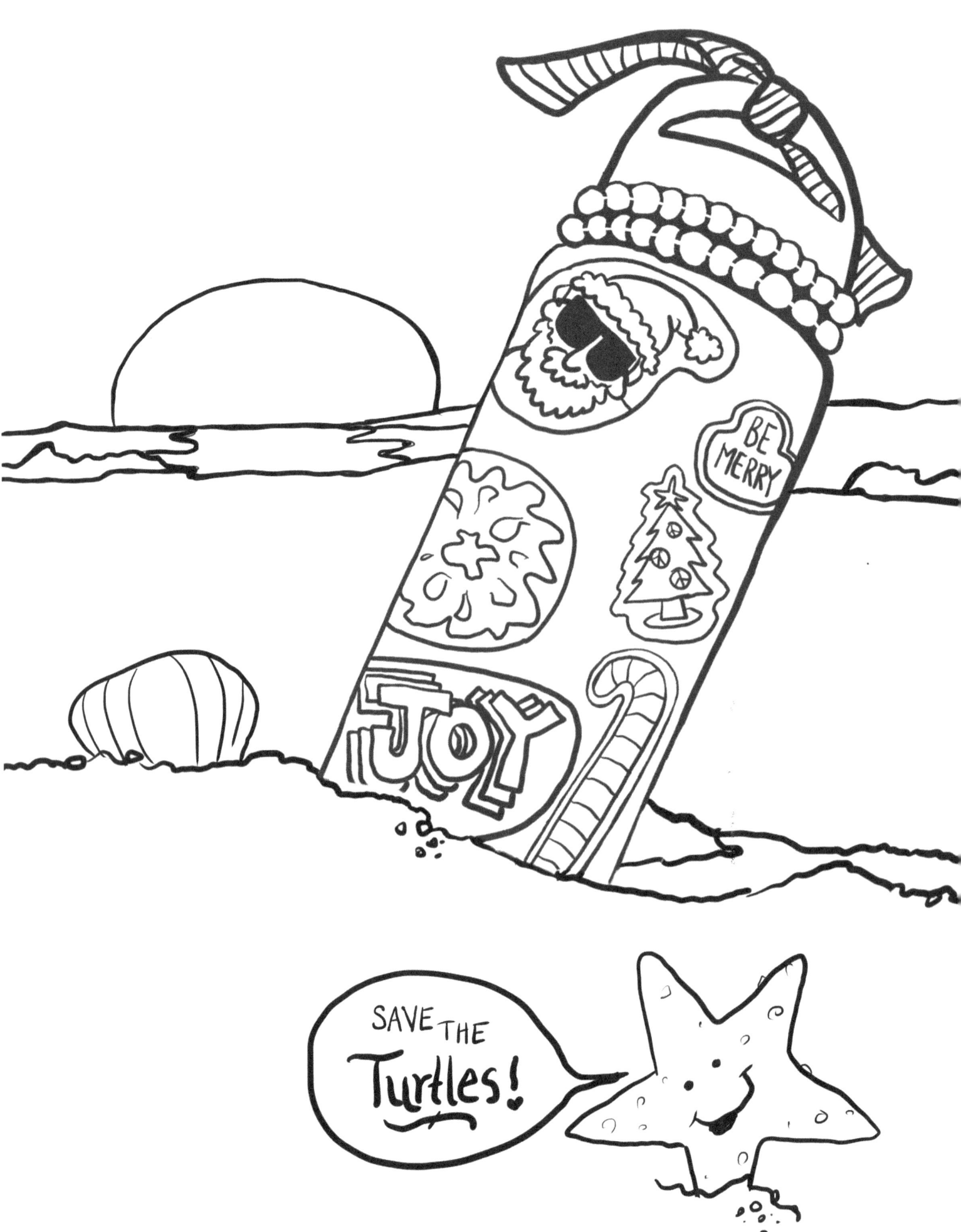

SAVE THE TURTLES

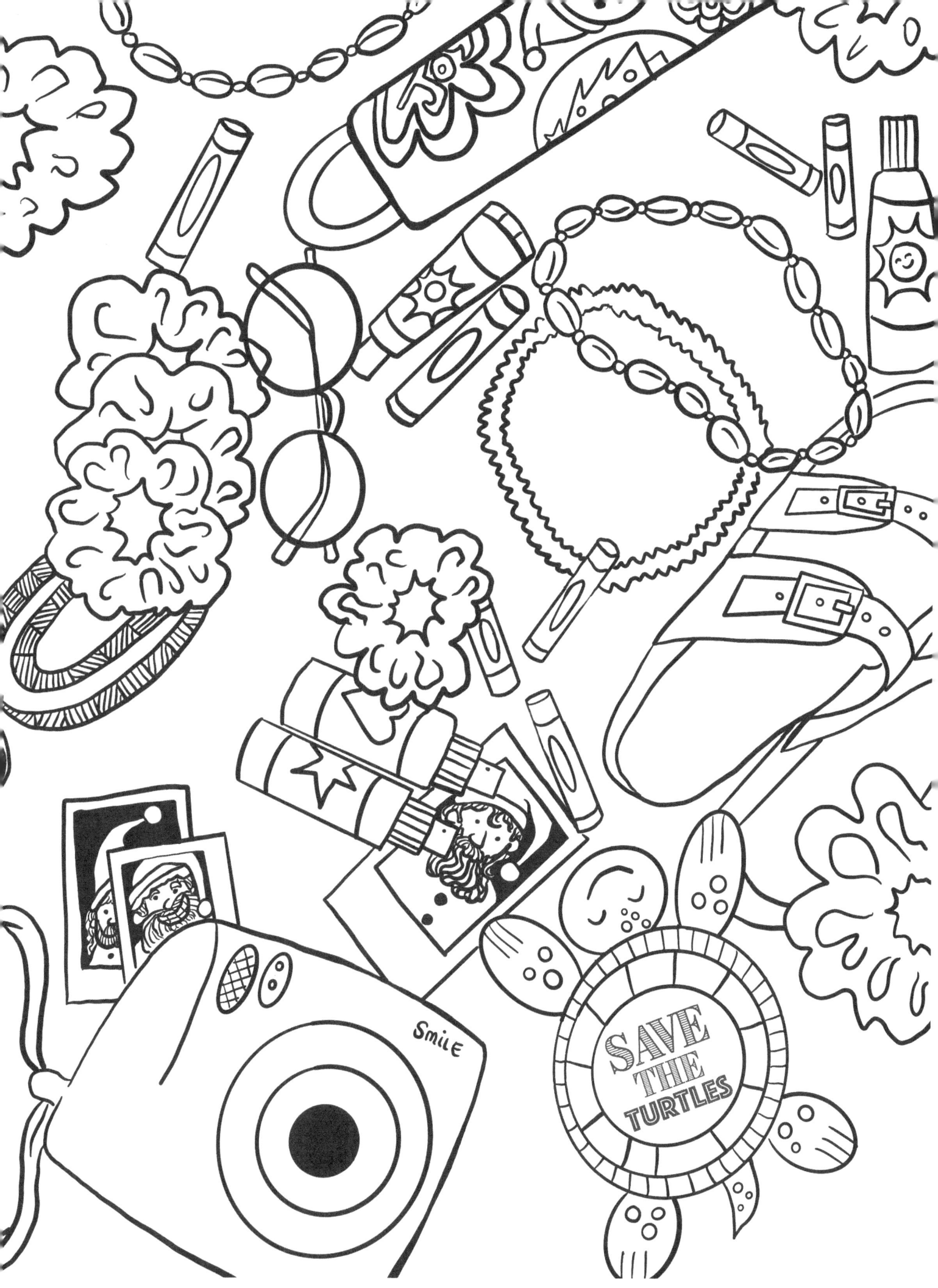

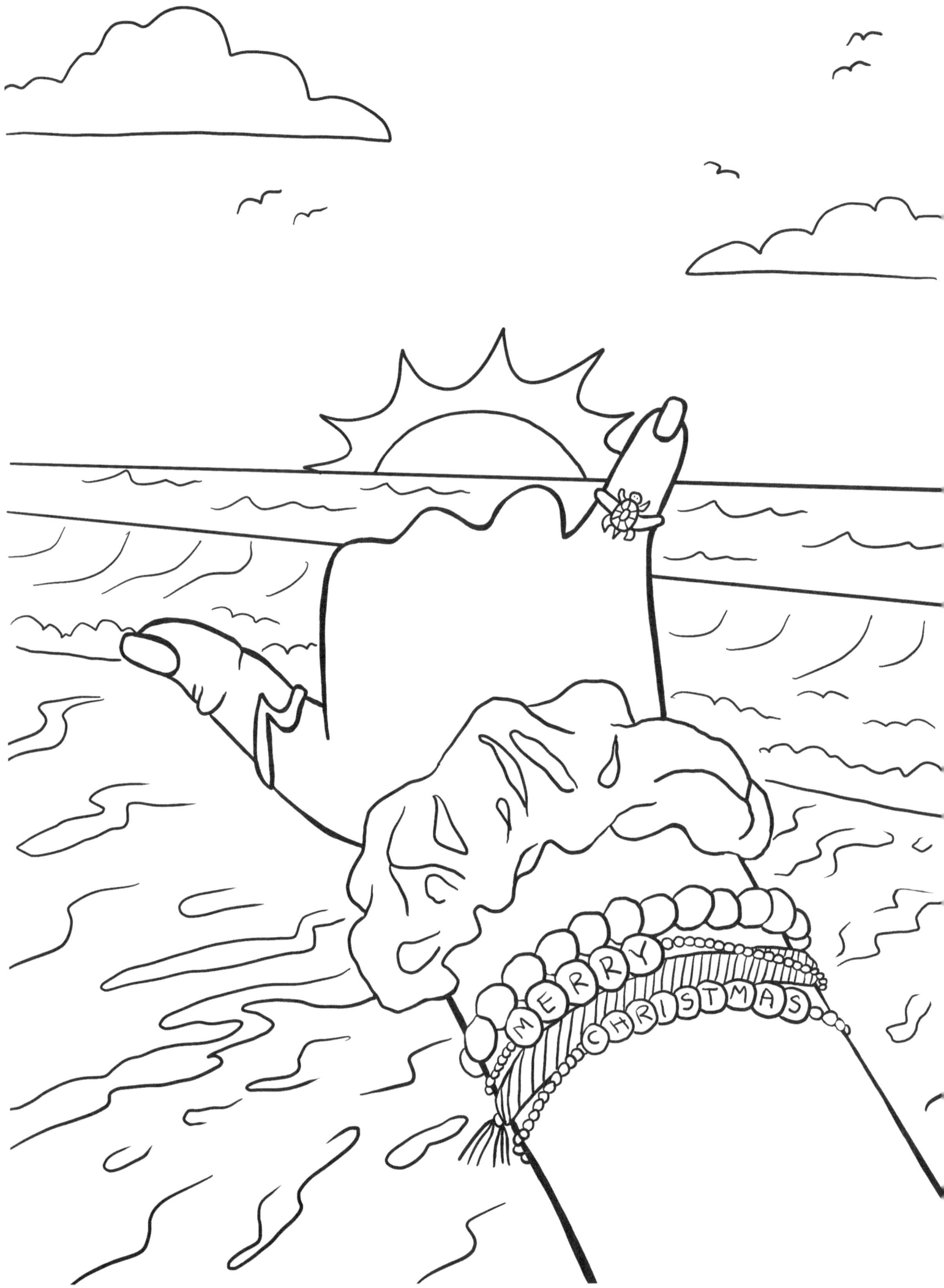

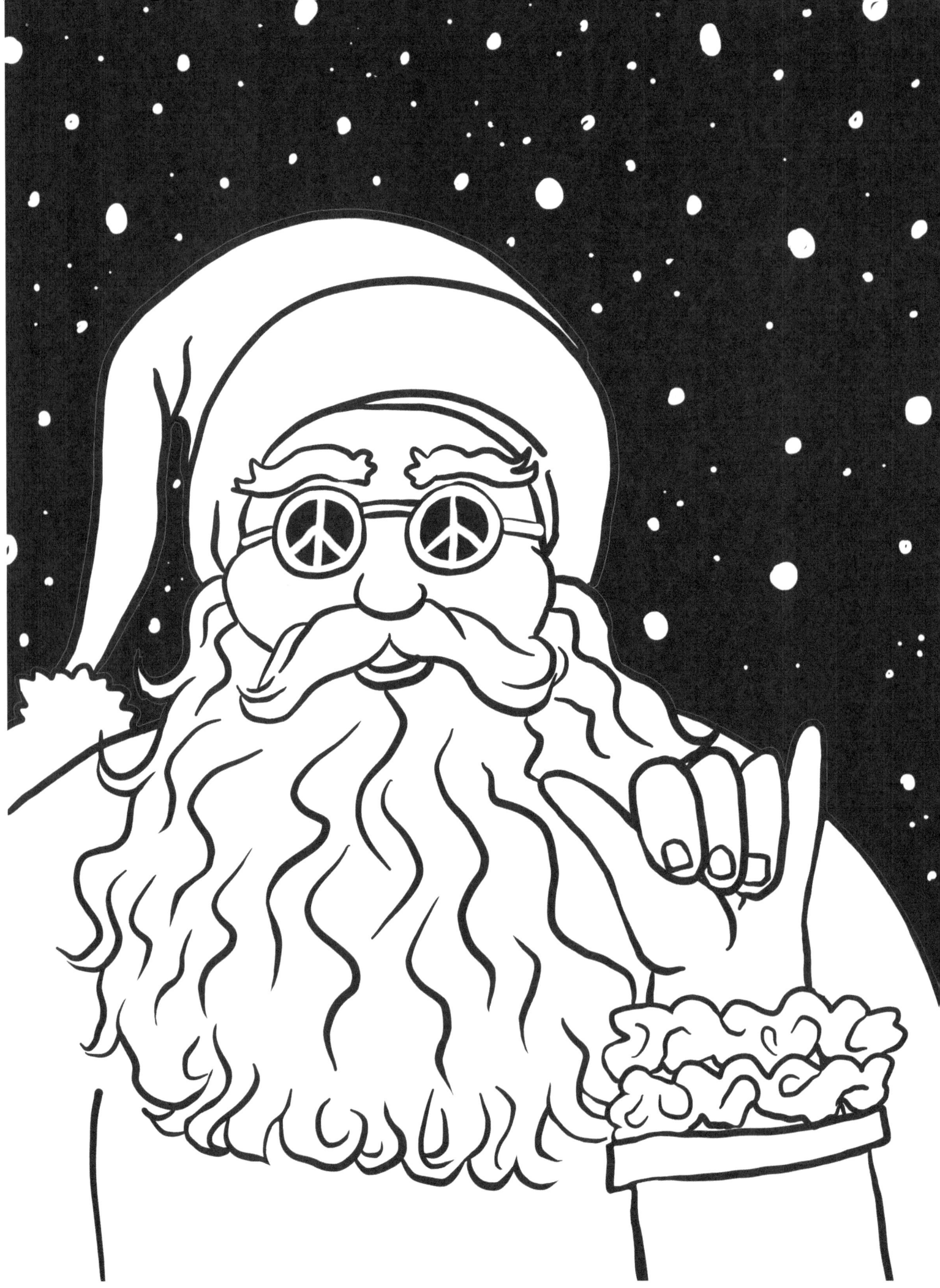

www.ingramcontent.com/pod-product-compliance
Lightning Source LLC
Chambersburg PA
CBHW080139240526
45468CB00009BA/2602